The primary aim of this series is not so much to learn as to destroy thousands of years of incremental progress in just a few short steps. These steps are as follows:

-A child must unlearn his own mind in order to mature.

- All aspects of identity- gender, race, colour and creed are fragile temporary constructs, which paper over the cracks of our true primal core.

- Communication is key, and we should learn to communicate all of our differences away, so that we become one huge blobby grey mass of love and acceptance.

Miriam Elia is headteacher at the London School of Racism, Sexism and Homophobia. She has successfully pioneered schemes of learning which deliberately discriminate against children.

Formerly a hard line capitalist, Ezra Elia's life was transformed by John Lennon's hit single 'Imagine' in 1970. He enjoys living in East London and evicting DSS tenants with right wing views.

M.Elia and [_____ ____]ee with.
policy of no [_____]

D0586503

In undermining everything that the child understands to be true, Dung Beetle advances its core principle of *development through total annihilation of self-worth*, so helping to create the next generation of kind, loving and utterly brainless intellectual elites.

KEY SUBTEXTS is a new experimental scheme exclusive to Dung Beetle Books, where children are given stepping stones to the interior meaning of a surface text. These come in the form of three key words, each of which give a clue to the authors' deeply sinister intent. Eventually, your children will soon learn to confuse insight with paranoia, and so develop a healthy, progressive outlook.

This book belongs to:

Book 1b

THE DUNG BEETLE NEW
WORDS READING SCHEME

We learn

at home

by
M. ELIA and E. ELIA
with illustrations by
M. ELIA

Dung Beetle Ltd © 2016
Printed in Poland by Polish people who fully endorse British values.

We are not going to school today.

Mummy is teaching us at home.

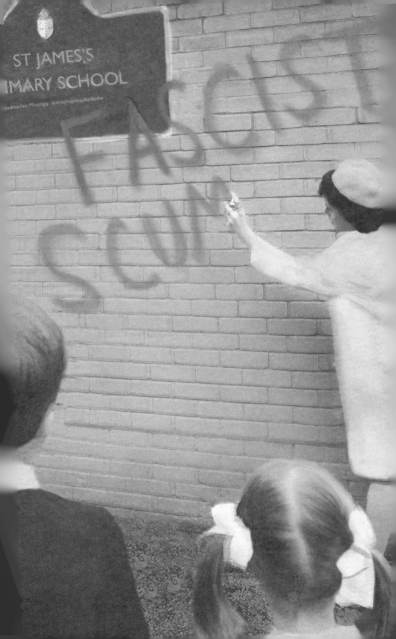

"What are we going to do?" asks John.

"We are going to ███████ the system," says Mummy.

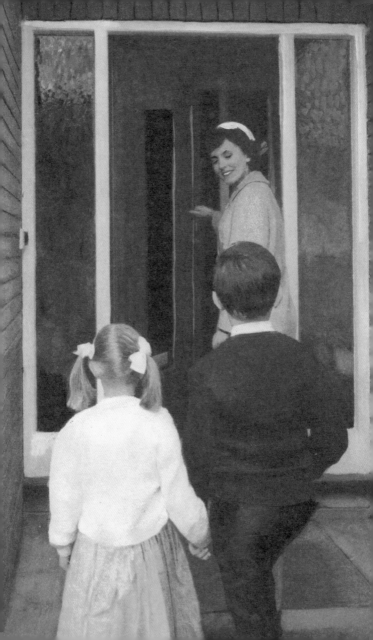

The sign is flashing.

"But we are at home," says John.

"Home is patriarchal incarceration," says Mummy.

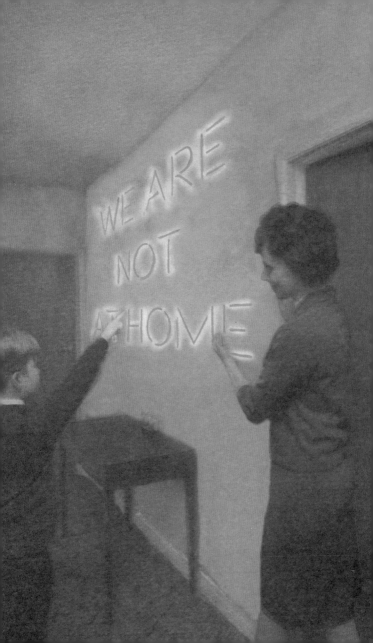

"This book tells us right from wrong," says Mummy.

"Can we read it?" asks John.

"No," says Mummy, "it is scientifically inaccurate."

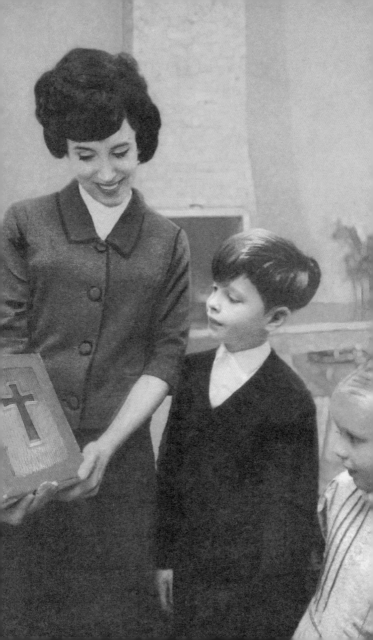

The facts are on the board.

"What are facts?" asks Susan.

"Facts are lies invented by white men to control women, gays and ethnics," says Mummy.

new words terminal thought cemetery

We are having a debate

"How do you win?"
asks John.

"You must tell the other
person they are hurting
your feelings," says
Mummy.

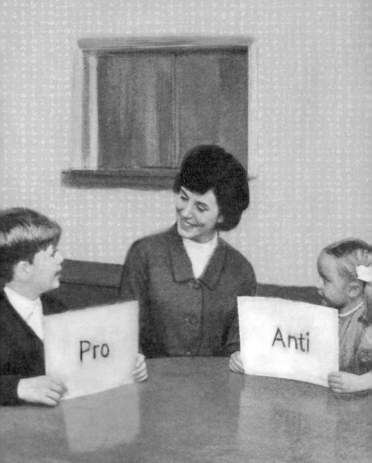

"This is Mr Id," says Mummy. "He represents your unconscious self."

"Hello Mr Id!" says Susan.

"I want to have sex with everything," says Mr Id.

new words randy repression puppet

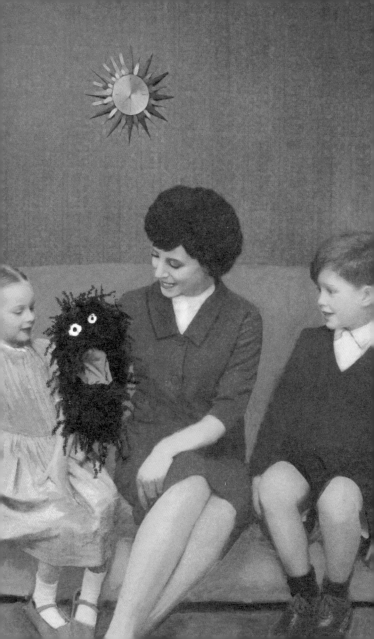

"What is the answer?"
asks Mummy.

"5," says Susan.
"Fascist!" says Mummy.
"You are excluding the
other numbers."

new words anti discriminatory mathematics

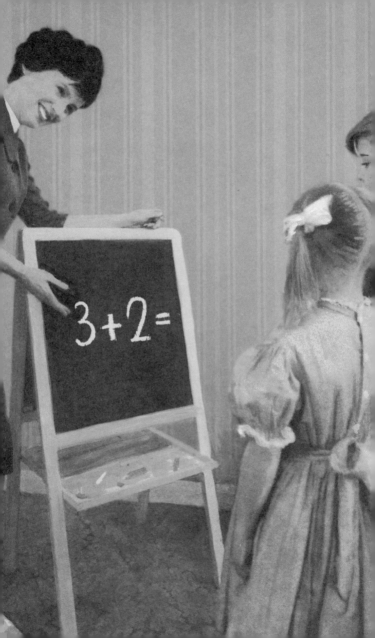

"Why are we throwing the books away?" asks Susan.

"Because they were written by the wrong people," says Mummy.

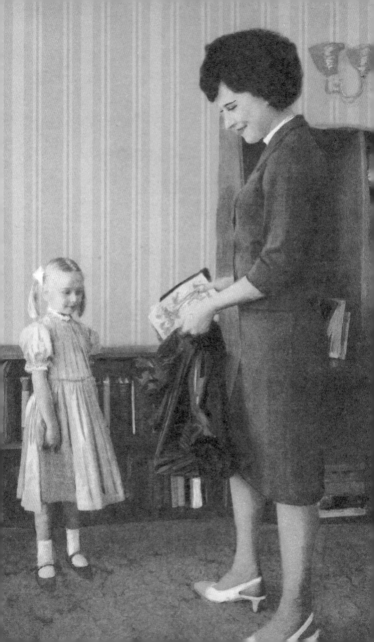

We are joining the society.

It is the society of kindness, happiness and love.

Together we can make a better world.

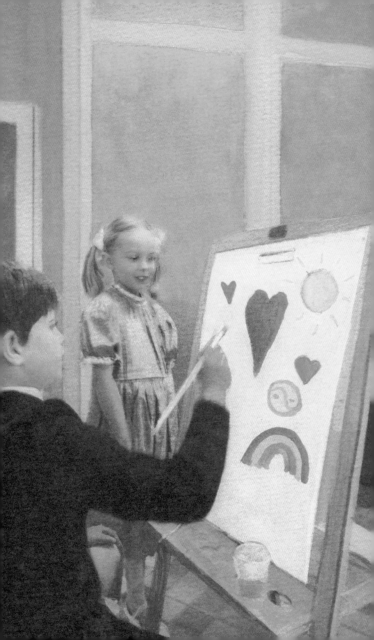

The hamster is a jihadi.

He wants to subjugate women, kill homosexuals and massacre the infidels.

But it is OK, because he is a hamster.

"I like his furry coat," says Susan.

new words soft nibbly extremist

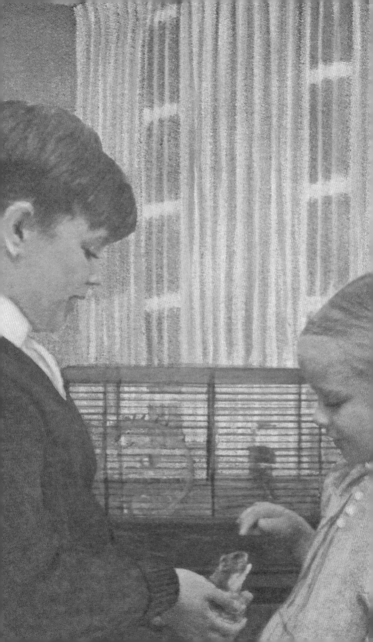

John is painting a picture.

"You must paint your inner child," says Mummy.

"But I am a child," says John.

new words repressed inner adult

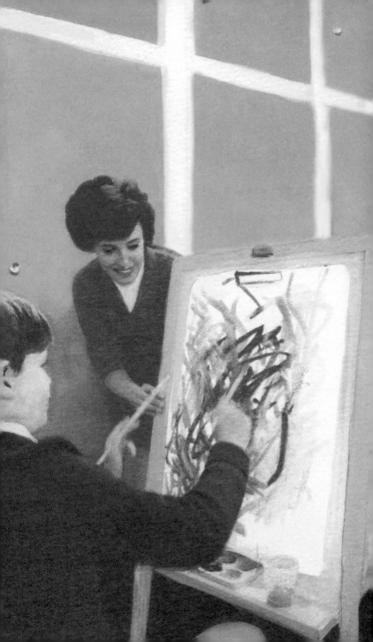

"One day, men and women will be equal," says Mummy.

"And when that day comes, we will beat them at everything."

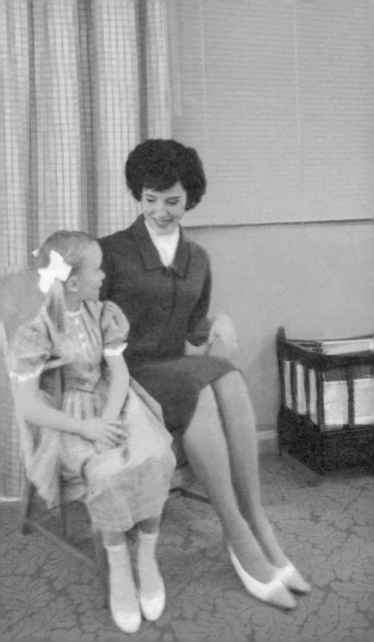

"What does the word mean?" asks Susan.

"It belongs to anyone that we disagree with," says Mummy.

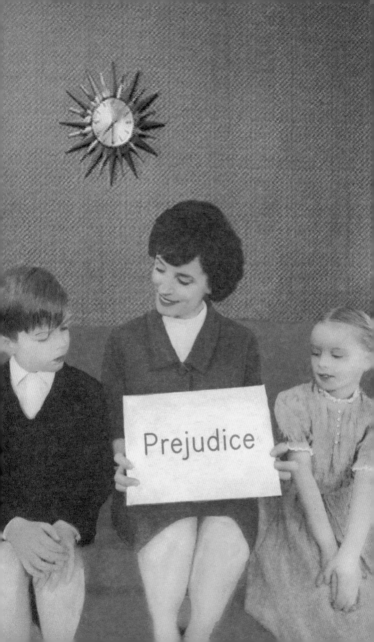

"Can I go to my room?" says John.

"No, I have donated it to all the victims of colonial-imperialism," says Mummy. "They are moving in tomorrow."

"Why are we burning the flag?" asks Susan.

"Because we do not exist," says Mummy.

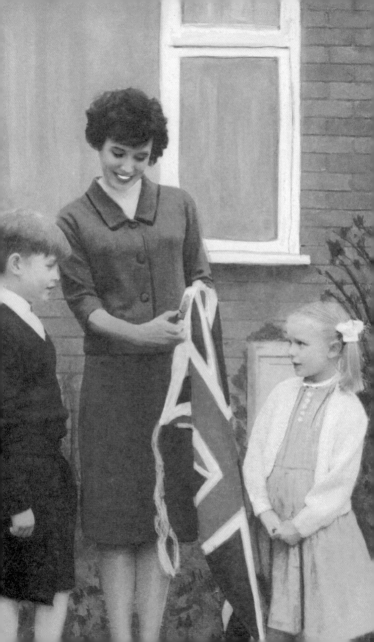

"This is my baby," says Jane.

"It is the end of your career," says Mummy.

new words cuddly cute redundan

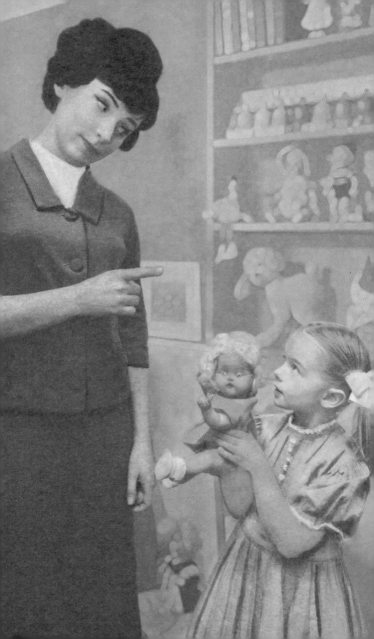

"How can I be successful?" asks John.

"You must become famous, and then kill yourself," says Mummy.

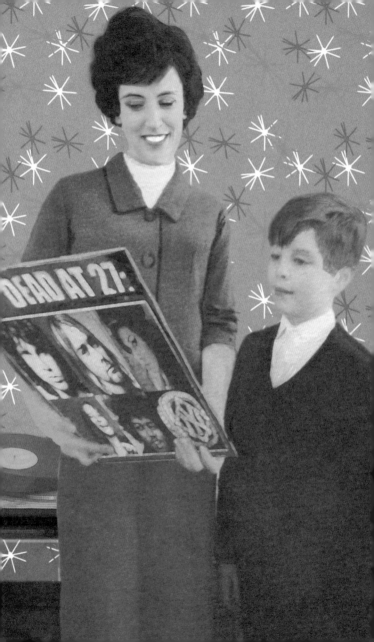

We are singing a song.

There are no lyrics.

There is no melody.

Mummy doesn't know how to play the piano.

new words random angst noise

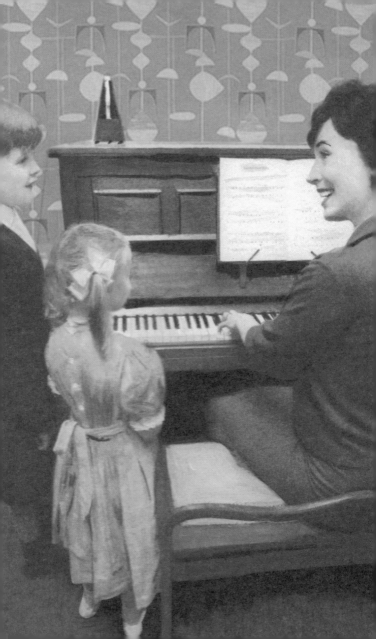

We are at the end of the book.

"I don't understand the story," says John.

"That is the moral of the story," says Mummy.

new words mystifying art sewer

New words used in this book

6 Mummy/ state/ control	26 Soft/ nibbly/ extremist
8 Me/ me/ me	28 Repressed/ inner/ adult
10 Daddy/ gender/ prison	30 Liberty/ equality/ revenge
12 Irrational/ science/ brigade	32 Semantic/ black/ hole
14 Terminal/ thought/ cemetery	34 Colonial/ charity/ bedroom/
16 Manipulate/ feelings/ win	36 Marx/ Buddha/ Marx
18 Randy/ repression/ puppet	38 Cuddly/ cute/ redundancy
20 Anti/ discriminatory/ mathematics	40 Celebrity/ death/ farm
22 Silence/ cognitive/ dissonance	42 Random/ angst/ noise
24 Kill/ the/ apostates	44 Mystifying/ art/ sewer

Total number of new words 60

Dedicated to the big mummy in the sky.

First published 2016 ©